Vive Le Color!

VITALITY

COLORING BOOK & PENCILS

ABRAMS NOTERIE, NEW YORK

Check out the full line of *Vive Le Color!* coloring books at **www.abramsnoterie.com**

ISBN: 978-1-4197-2055-0

Copyright © 2015 Hachette Livre (Marabout)
Illustrations © Shutterstock
Design: Else

English translation copyright © 2015 Abrams Noterie

Printed and bound in China
10 9 8 7 6 5 4 3

Abrams Noterie products are available at special discounts when purchased in quantity for premiums and promotions as well as fundraising or educational use. Special editions can also be created to specification. For details, contact specialsales@abramsbooks.com or the address below.

ABRAMS
THE ART OF BOOKS SINCE 1949
115 West 18th Street
New York, NY 10011
www.abramsbooks.com

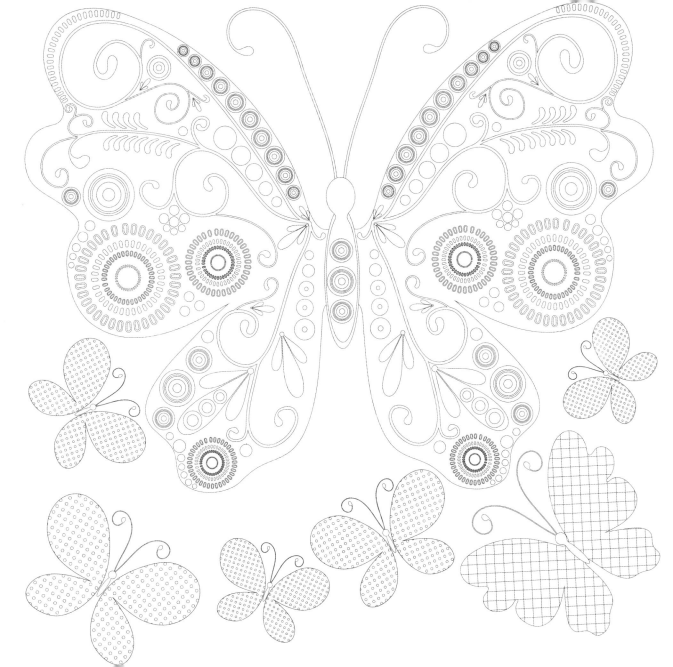

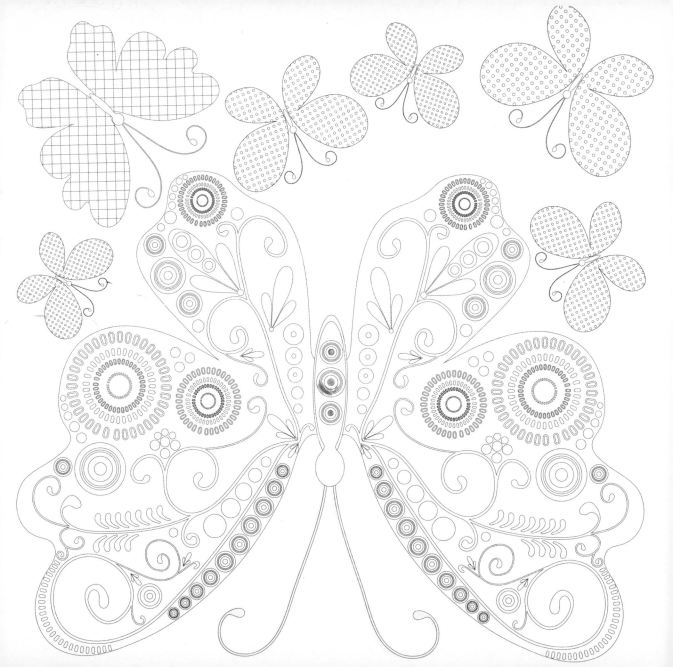

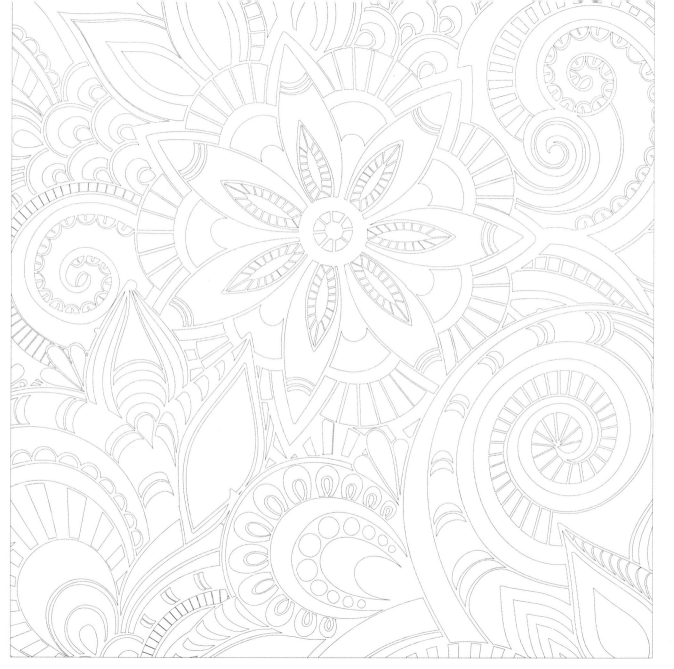

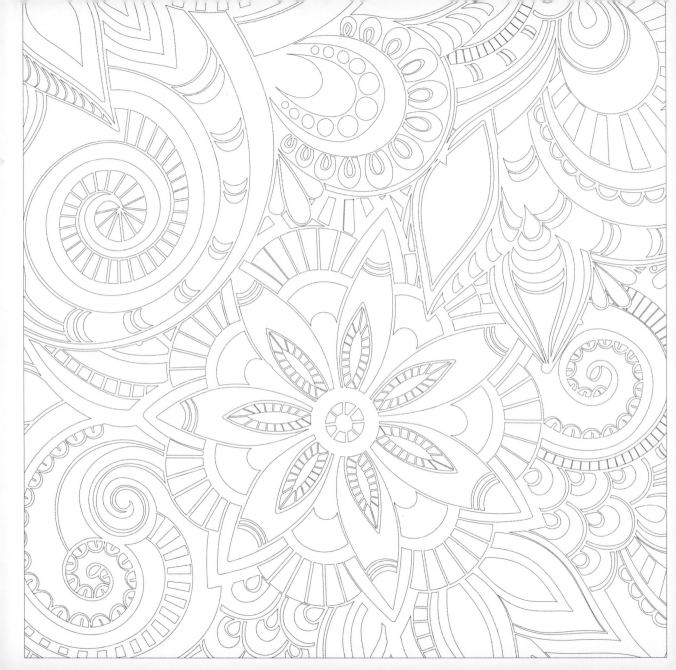

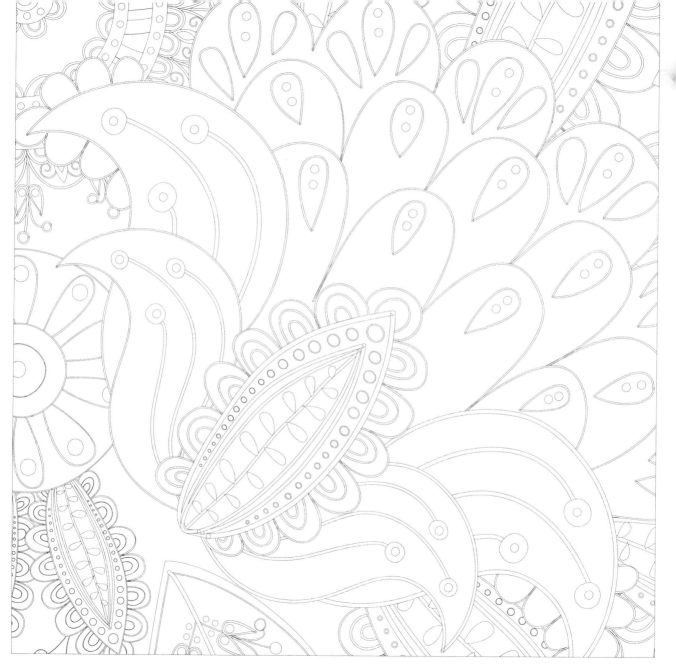

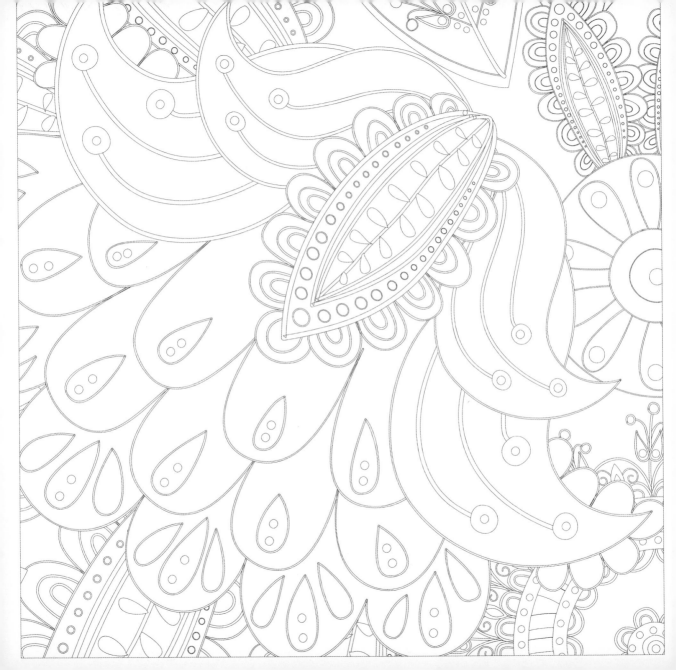

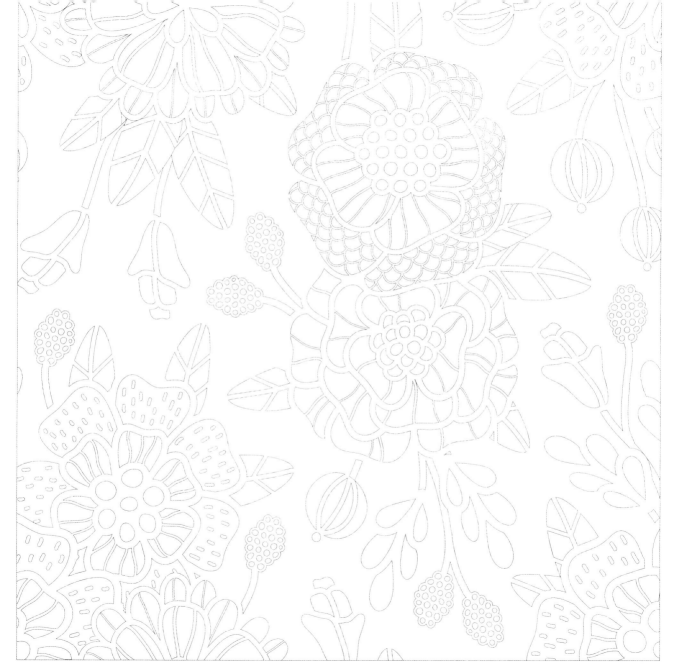

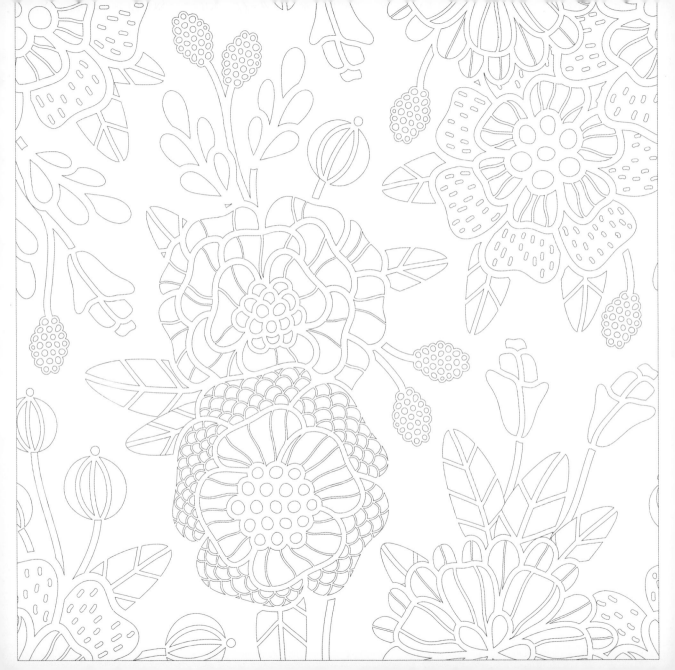